Figures of History

T0087427

Figures of History

Jacques Rancière

Translated by Julie Rose

polity

First published in French as *Figures de l'histoire* © Presses Universitaires de
France, 2012

This English edition © Polity Press, 2014
Reprinted 2015

Cet ouvrage publié dans le cadre du programme d'aide à la publication a
bénéficié du soutien du Ministère des Affaires Etrangères et du Service
Culturel de l'Ambassade de France représenté aux Etats-Unis.

This work received support from the French Ministry of Foreign Affairs and
the Cultural Services of the French Embassy in the United States through
their publishing assistance programme.

Cet ouvrage a bénéficié du soutien des Programmes d'aide à la publication
de l'Institut Français.

This work, published as part of a program of aid for publication, received
support from the Institut Français.

Polity Press
65 Bridge Street
Cambridge CB2 1UR, UK

Polity Press
350 Main Street
Malden, MA 02148, USA

ISBN-13: 978-0-7456-7956-3
ISBN-13: 978-0-7456-7957-0 (pb)

A catalogue record for this book is available from the British Library.

Typeset in 12.5 on 15 pt Adobe Garamond
by Toppan Best-set Premedia Limited
Printed and bound in the United States of America by RR Donnelley

For further information on Polity, visit our website: politybooks.com

The original French publisher, Presses Universitaires de France (PUF), would like to thank Aliocha Wald Lasowski for his help in compiling this book.

Contents

Note on the text

The two texts brought together here are part of the same project. They were both written on the occasion of the exhibition 'Face à l'Histoire', which was held at the Centre Pompidou in 1996. Jean-Paul Ameline, the curator, asked me for the essay 'Senses and Figures of History' to include in the exhibition catalogue. Running in parallel with the exhibition, the public library at the Pompidou screened a series of documentary films on the same theme. It was in that context that Sylvie Astric commissioned 'The Unforgettable', which was included with an essay by Jean-Louis Comolli in Arrêt sur Histoire, published in 1997 in the 'Supplémentaires' series of the

Editions du Centre Pompidou. I would like to thank the French publisher for allowing these two essays to be reprinted in the present volume, as they are otherwise unobtainable.

J.R.

Part 1

THE UNFORGETTABLE

1 In front of the camera lens

It is an image from turn-of-the-century Saint Petersburg, both ordinary and extraordinary at the same time. The imperial family is passing by, surrounded by an escort of officers and dignitaries. The crowd gathered there, at the side of the road, is addressed by an officer with an imperious gesture: when the Tsar passes, the thing to do is to remove your hat. The commentator's voice is heard: I don't want this image to be forgotten.

What is Chris Marker trying to tell us by placing this image at the opening of his 1993 film, *The Last Bolshevik*? Is he trying to say that the people really were oppressed and humiliated in Russia in the early twentieth century and

that, in today's latest round of score-settling with the communist era, we should not forget what came before that era and justified its coming? The objector will swiftly reply that the evils of the day before yesterday do not justify those of yesterday, which, in any case, were worse. What *is* can never be justified by what *was*, no matter what conclusions we draw about the past. Or, rather, such conclusions belong entirely to the realm of rhetoric. It is only there that images suffice as evidence. Elsewhere, they merely show, merely provide a record for posterity. The image of General Orlov and his men imposing a duty of respect on the crowd doesn't tell us that, all the same, the Bolsheviks had their reasons and their excuses. It tells us both less and more: this *was*, it is part of a certain history, it is history.

This was. Our present is not beset by scepticism, as people often claim, somewhat superciliously. It is beset by negation.[1] If the provocation of denying the Nazi extermination camps has resisted attack and is even gaining ground, this is because it is synchronous with this spirit of the

1 Translator's note: The French word for Holocaust denial or revisionism, is *négationnisme*. A revisionist is a *négationniste*.

4

times, a spirit of resentment, *ressentiment*: not just resentment of the ideals of the new man which people believed in, or resentment of the people who got you to believe in those ideals or the people who destroyed them and brought about the general loss of faith. The object of resentment, Nietzsche tells us, is time itself, the *es war: this was*. Resentment is sick of hearing about this past of the future, which is also a future of the past. It has had it with those two tenses, which are so good at conjugating their double absence. Resentment is only interested in knowing time without the trickery: the present and its *conjoncture*, its conjunction of circumstances, as a present that we go on counting endlessly to reassure ourselves that it is woven out of the real and nothing but the real: the time involved in ratings that are expected to recover next month or polls that are supposed to track the same trend one month later. Just as resentment abhors the times and tenses of absence, so it abhors images, which are always of the past and which have probably already been doctored and trafficked by the false prophets of the future.

But the camera lens is indifferent to all that. It doesn't need to insist on the present. It cannot

not be in it. It has neither memory nor ulterior motive and, so, no resentment, either. It records what it has been told to record: the imperial family's royal procession at the beginning of the twentieth century; or, thirty or forty years later, mobile human pyramids in Red Square bearing vast effigies of Stalin at their apex, which pass before Stalin himself, who applauds his image (*Rothschild's Violin*). Someone in power not only allowed images to be made of these parades, which look so damning to us; he ordered that they be made. Just as some other authority, in Indonesia, commissioned those images of local children twisting their mouths in an effort to learn to speak the language of the colonizer properly; or those images of faces in tears before a portrait of Stalin in Prague in 1953. The camera has captured these images faithfully. But, of course, it did so after its own fashion, as a double agent faithful to two masters: the one behind the camera who actively directs the shot, and the one in front of the camera who passively directs the camera's passivity. In Jakarta, the camera recorded the rapt attention of a child who is so much more anxious to do well than the cameraman is (*Mother Dao*). In Prague, it not only noted

the faces saddened by the death of the Father of the People. It also noted how the photo of Stalin sat behind a glass pane, in a little niche similar to the ones where people used to put statues of the Virgin Mary in the recent past and where they may well put them again in the near future. (*Words and Death. Prague in the Days of Stalin*). And so faithfully did it reproduce the defendants in the Prague trials, confessing and explaining their guilt, that the rolls of film had to be consigned to the cupboard and concealed even from those who had attended the trials and been convinced by what they had heard. The mechanical eye of the camera calls for an 'honest artist' (Epstein) and unmasks the one who has only learned his role for an occasional audience.

This was. This is part of a story. To deny what was, as the Holocaust deniers are still showing us, you don't even need to suppress many of the facts; you only need to remove the link that connects them and constitutes them as a story. A story, *une histoire*, is an arrangement of actions according to which there has not simply been this and then that, but a configuration that fits the facts together and allows them to be presented as a whole: what Aristotle calls a *muthos*

– a storyline, or plot, in the sense in which we speak of the plot of a play. Between the image of General Orlov and the images of the Soviet epic and its disastrous collapse, there is no causal link that could legitimate anything whatsoever. There is simply a story that can legitimately include them both. For example, the story entitled *The Last Bolshevik*, which ties all sorts of other images into the official image of the royal procession: images such as those from the rediscovered footage of Alexander Medvedkin's films which, in various modes, accompanied the different phases of the Soviet epic. These range from the surrealist images of *Happiness*, whose burlesque lightness of touch seems mockingly to undermine the promises of the official version of happiness, despite the conformism of the script, to the militant images produced by the cine-train, rolling across Russia to shoot from life and immediately relay to the interested parties the debates of people taking control of factories, land or housing; from official images made surrealist – or surrealist images made official? – produced to celebrate the work of the architects of the *New Moscow*, to interviews with people close to the filmmaker or researchers busy reviving his œuvre

and status, to images that speak volumes about the Russia of today, such as parties held by merry – and, Marker would have us believe, gilded – youth toppling statues. They range from images of the renewed pomp of religion, similar to that staged by the man who made *Ivan the Terrible*, perhaps to embrace, in a single sweeping glance, the Russia of the Tsars and the priests and the Russia of the Soviet dictator, and to the enigmatic image of an old man with an inscrutible face taking part in a ceremony. He turns out to be Ivan Koslovsky, the Russian tenor par excellence, a man who traversed the torments of the century imperturbably singing the muted melody of the Indian merchant in *Sadko* or Lensky's farewell lines in *Eugene Onegin*:

> *Where, oh where have you gone,*
> *Golden days of my youth?*

This makes a story. But also a history of a certain era: no longer just an arrangement of actions in the Aristotelian manner, but an arranging of signs in the Romantic manner: signs that immediately talk and fall into place in a meaningful storyline; signs that don't talk, but merely

signal that there is history-making material there; or signs that, like Koslovsky's face, are undecidable – like the silence of an old man, meditative as a person is at that age, or like the muteness of two centuries of history, the history of the Russia of Pushkin and Tchaikovsky within the history of Soviet Russia.

So, we are talking about a history of a certain era, *a story from the time of history*. That expression, too, is suspect these days. The current Zeitgeist assures us that all our troubles stem from the malevolent belief in history as the process of truth and the promise of completion. It teaches us to separate the task of the historian (*doing history*) from the ideological mirage according to which mankind or the masses would supposedly *make history*. But doesn't this convenient dissociation obscure the very thing that makes for the peculiarity of the image with which we started this essay – namely, the way the princes passing by and the crowd which parts for them as they pass share the same light and the same image? Maybe this is what the 'age of history' is, quite simply, at least to begin with. Long ago, in the days of history painting, people painted images of the great and their deeds. Of course the hordes

and humble people could be in the picture, too. It would be hard to conceive of a general without troops or a king without subjects. Occasionally, the hero would address them. Occasionally, the roles might actually be reversed and the old soldier, in great distress at the sight, would recognize his general, the Byzantine General Belisarius, in the beggar crouching at his feet. But there was nevertheless no common fate, shared between the man of glory subject to glory's reversals and the 'ignoble' man, excluded from glory's order; between generals fallen on hard times and the ill-born, who had already 'sunk into anonymity', in Mallarmé's phrase. The old soldier's image could share the canvas with that of Belisarius. But he did not share the story of the honest Belisarius's greatness and decline. That particular history belonged to Belisarius's peers alone, and for them it was supposed to recall two things that were of interest only to them: that fortune is inconstant, but that virtue, on the other hand, never fails the man who has cultivated it. The name 'history' was given to the anthology of such great examples, worthy of being learned, represented, meditated upon, imitated. Each one taught only its own lesson, unchanging over

time, and intended only for those whose vocation it was to leave behind a memory of their actions and accordingly draw an example from the memorable deeds of other men worthy of being remembered.

But the image of General Orlov offers instruction of quite a different kind, precisely because it wasn't made in order to provide anything whatsoever to meditate upon or imitate. The person who took it was not intending to remind us of the respect due to royalty. He took it because it is only normal to get down all that the great and the good do when they're putting themselves on show, and since machines can do this automatically, these days. Yet the machine makes no distinction. It doesn't know that there are genre paintings and history paintings. It takes both the great and the small and it takes them together. It doesn't make them equal by virtue of who knows what mission of science and technology to bring about a democratic reconciliation between noble and humble ranks. It simply makes those ranks liable to share the same image, an image of the same ontological tenor. It does so because, for the image itself even to exist, those disparate ranks had to have something in

common already: they belonged to the same period of time, to precisely that time we call 'history' – a time that is no longer an indifferent anthology of memorable actions, intended for those who are supposed to be memorable too, but the very stuff of human action in general; a time that is qualified and oriented, that carries promises and threats; a time that levels all those who belonged to it – those who belonged to the order of memory and those who did not. History has always been the story of the people who 'make history' exclusively. What changes is the identity of the 'history makers'. And the age of history is the age where anyone at all can make history because everyone is already making it, because everyone is already made by it.

History is that time in which those who have no right to occupy the same place can occupy the same image: the time of the material existence of the shared light of which Heraclitus spoke, the sun of judgment none of us can escape. It is not a matter of any 'equality in rank' in the eyes of the camera. It is a matter of the twin mastery the camera prompts, the mastery of the operator and that of his 'subject'. It is a matter of a certain sharing of the light, a sharing

whose terms Mallarmé undertook to define, a few years before the image we're dealing with here was taken, in the extraordinary prose poem entitled 'Conflict'. This is about the conflict between the poet and those bores, the railway workers who, laid out by heavy Sunday drinking sessions, 'close off, by their abandon, the vespertine distance'. It's about an internal conflict as well, over the duty incumbent upon the poet not indecorously to step over the 'carpet of the scourge' of which he must 'understand the mystery and judge the duty'.

'The constellations begin to shine: how I'd like it if in the darkness that runs over the blind flock, points of light, like that thought just now, could be fixed, in spite of these sealed eyes not making them out – for the fact, for the exactness, for it to be said.' The French poet wanted to steal from the brightly shining stars the right light not only for illuminating the workers' faces, but to consecrate the shared sojourn. To that dream, as to all dreams, a German philosopher had already responded, some little time before, in his taunting way: 'Human beings only ever ask themselves questions they can answer.' Fixing points of light over the ill-born, sunk into anonymity

– that had already been done, technically, routinely. It was called photography, which is writing with light; and with the advent of photography, all lives entered the shared light of a writing of the memorable. But the idealist poet, who dreamed of new 'acts of worship' by and for the community, may well have seen the central point more clearly than the materialist philosopher of the class struggle: light itself is an object of sharing and distribution, *partage*; but it is only conflictually common. The equality of all before the light and the inequality of the little people as the great pass by are both written on the same photographic plate. This is why we can read, on that plate, what it was actually pointless looking for in the painting of Belisarius as a beggar: the commonality of two worlds in the very gesture of exclusion; their separation in the commonality of one and the same image. This is why we can also see there the commonality of a present and a future, the future Mandelstam was to celebrate in 1917 in two deliberately ambiguous lines:

> *O Sun, judge, people, your light*
> *is rising over sombre years.*

But the sentence of light is not only, as some would have it, the history of the new myths of the red sun and the bloody catastrophe they led to. It may, more simply, be the 'justice' that the images from *Mother Dao* do to the colonized of the recent past. Dutch colonizers in Indonesia took those images to celebrate their work civilizing the natives. In the forest where wild creatures once lived, a humming hive of industry now rose and in it their sons gained skill, dignity and a salary by extracting and forming metal. At school, in the dispensaries, grown-ups and children consented to the teaching that elevated them, to the hygiene of showers, to the vaccinations that saved their bodies and to the signs of the cross that saved their souls. These images of the recent past have been organized differently by Vincent Monnikendam. And the underlying principle of their reorganization is not to show the dark underside of oppression beneath this civilizing parade, to move from the 'happiness' pictured by the colonizer to the unhappiness and revolt of the colonized. No doubt the poetic *voice off* that accompanies the images voices the suffering of the earth and of a life that aspires to resume the 'course of its thoughts'. But this very

accompaniment is not so much a counterpoint to that suffering as the manifestation of a capacity for voicing the situation, for turning it into fiction. What it thereby accompanies on screen is a minute yet decisive change in the appearance of the faces and attitudes of the colonized, in the 'happiness' they express: they respond to the surprise of these imposed exercises with attention, with a certain pride in playing the game, as perfectly as possible, before the blackboard at school or the iron at the forge. They quietly assert their equal aptitude for all kinds of learning, for all the rules and every kind of contortion; they assert their equal intelligence. And watching the face of the little girl who takes such pains to spell the master's language correctly, we seem to catch an echo of a moment of sentimentality on the part of the ironist Karl Marx, when he recalls the gatherings of the League of the Just and celebrates the 'nobility of man' that 'shines from the workers' brows'. It is a nobility of the same kind that makes the eye of the camera wielded by the colonizer shine. Consciously or unconsciously. Intentionally and beyond what was intended.

2 Behind the window

Cinema, says Manoel de Oliveira, as reprised by Jean-Luc Godard, is 'an overload of magnificent signs bathing in the light of the lack of any explanation for them'. It's a nice turn of phrase, but it needs to be completed. For the lack of an explanation is only magnificent as an abandonment or suspension of explanation: a suspension between two different regimes of explanation. Explaining actually means two quite different things. It can mean providing the sense of a scene, the reason for an attitude or an expression. But, according to the etymology of the word, explaining can also mean letting the scene, or attitude or expression, unfold the fullness nestled in its simple presence. By cutting the thread of

any reason, you leave the scene, the attitude, the face, with a muteness that gives them double the power: stopping the gaze on this evidence of an existence linked to the very lack of a reason, and unfolding that evidence as a potentiality belonging to another sensory world.

A young girl stands at a window, absorbed in contemplating beanpoles knocked over by the wind. She turns round and asks the visiting doctor what he's looking for, though we didn't know he was looking for anything. Two bodies brush against each other as they both grab a riding-crop. The next day the doctor is back. Nothing has been explained. Simply, in the vacuum of explanations, Flaubert has found a way of taking a room in a Normandy farmhouse and, in its place, deploying the great vacuum, the 'great ennui', of the Oriental desert he is in love with, that infinity of grains of sand that is itself just like the vacuum that tosses atoms around indiscriminately. And out of that particular vacuum, he creates the very place of Charles's love for Emma. This is the romantic principle of indeterminate significance or determined insignificance. The absolute power of art whereby 'Yvetot is as good as Constantinople', is possible

only on the basis of such a pact with the insignificant. But as a result of that pact, any ordering of actions is doubled by a sequence of images that takes away that ordering's intentionality and puts it on a par with the great passivity of the real. And also as a result of that pact, Charles and Emma's unhappiness is the exact flipside of the capacity of any life to be memorable.

The privilege of the cinematographic image is that it derives 'naturally' from this indeterminate significance which, in the age of history and of aesthetics – in the Romantic age, in short – turns any life whatever into the stuff of absolute art. Flaubert had to construct this regime of insignificant significance through endless subtraction. But cinema, with its conscience-free eye, has a tool that can precisely enact the Romantic concept of the work of art as the equality between a conscious process and an unconscious process. So, cinema is an art that is 'immediately' Romantic. It spontaneously applies the principle of the double mechanism that ballasts any sign of splendour with its insignificance and with the infinitude of its implications. We see this at work in the urban Emma Bovary filmed in cinéma-vérité mode in 1929 by the young directors of

People on Sunday. What does she really think of
the fop who, like Rodolphe, dragged her aside
beneath the tall forest trees, this young shop
assistant who has come out for a day in the
country to accompany her female friend and to
show off her new portable gramophone, the
latest model? What does the friend think when
she (accidentally?) breaks the record we've seen
playing, in the sun, level with people's faces,
without hearing any of it, of course, since the
film is silent? What do either of the girls think
of these men, one of whom one of the girls has
given herself to, the other being rejected, when
they exchange a knowing look on the boat going
back? But what does an image think anyway?

And where is the history in all that? What
precise relationship is there between the drab
everyday life or small Sunday pleasures of big-
city working girls and cinema's vocation to act as
a kind of history in the form known as 'docu-
mentary'? It is this: the age in which cinema
realizes its powers is also the period when a new
science of history asserts itself in the face of the
history chronicle, or history-as-chronicle – that
'factual' history that did the history of illustrious
figures with the aid of the 'documents' of their

secretaries, archivists and ambassadors – in short, with the documents of the illustrious figures' officials. That history, made from the very traces those memorable men chose to leave, was now opposed by a history made from traces no one chose as such, the silent testimonies of ordinary life. The *document*, the text on paper intentionally written to make a memory official, was now opposed by the monument, in the primary sense of the term as that which preserves memory through its very being, that which speaks directly, through the fact that it was not intended to speak – the layout of a territory that testifies to the past activity of human beings better than any chronicle of their endeavours; a household object, a piece of fabric, a piece of pottery, a stele, a pattern painted on a chest or a contract between two people we know nothing about and which reveals an everyday way of being, a business practice, a sense of the love or of the death inscribed there, for itself, without anyone thinking of future historians. The monument is the thing that talks without words, that instructs us without intending to instruct us, that bears a memory through the very fact of having cared only for the present.

But, of course, the clear opposition between the monument and the document is no such thing. The historian has to get the 'silent witnesses' to talk, to state the sense of them in the language of words. But the historian must also take what was written in the language of words and with the tools of rhetoric and re-read it, delving beneath what the words say and dredging up what they say without thinking, what they say as monuments, as opposed to what they say intentionally. Accordingly, in the official proceedings of the Festival of Federation of July 1790, Michelet reads the 'monuments of fledgling fraternity'. But in order to read these 'monuments' of shared thought in those records and allow us to read them too, he had to erase the rhetoric of the village scribes and get what they were expressing to talk in their stead: the very spirit of place, the power of nature at harvest time, the power of the different ages and generations gathered together around the birth of the nation, from the venerable old man to the newborn babe. The new history, the history involving 'the time of history' (the mid-to-late nineteenth century), can only maintain what it is saying at the cost of endlessly transforming

monuments into documents and documents into monuments. That is, it can only maintain what it is saying through the Romantic poetics that constantly converts the significant into the insignificant and the insignificant into the significant.

But then, if cinema in general is a matter of the Romantic poetics of double significance, we can see that 'documentary' cinema is a very specific instance of this. Its very vocation as the revealing (*monstration*) of the 'real' in its autonomous significance gives it, even more than fiction film, the possibility of playing with all combinations of the intentional and the unintentional, all transformations of documents into monuments and monuments into documents. To grasp the underlying mechanism at work here and its import, let's transport ourselves from that sunny afternoon on the Wannsee to an evening on the shores of the English Channel, a few years later. The sun is setting between bands of clouds and reflections on the sand. From behind, against the light, the camera shows us two men on a seat watching the sun go down and the endless movement of the waves. There they are, apparently immobilized before this perpetually similar

movement and the ever-changing light, like Bouvard, on the Hachettes coast, forgetting Pécuchet and the purpose of their geological excursion, just to watch the endless movement of the waves that may well be all there is to know about 'nature' and its secrets. The camera, however, has moved. Against the same sea background, it presents us with another backlit silhouette. But the helmet covering the man's head makes us realize that these two idlers are actually two English coastguards observing not the limitless sea but the ever-possible arrival of the German enemy.

The film is called *Listen to Britain*. It is especially intended for the Canadians. And its object is to show, from the other side of the Atlantic, how the British people as a whole are facing up not only to the Germans, but to their historic mission on behalf of humanity. But its director, Humphrey Jennings, had a singular take on his work of propaganda for a country resisting the enemy's bombs. His film shows us neither shelling nor damage. The bird-planes barely even disturb a fertile country landscape that looks like something straight out of an Alexander Dovzhenko film. As for the soldiers, we only ever

see them in their moments of leisure: in a carriage on a train, where they sing along to a guitar and accordion, a melancholy song about a house in the country with deer and antelopes; in a ballroom, where they dance; in a concert hall, where Myra Hess plays a Mozart concerto for them; in a village parade, similar in style to Bastille Day in France, where they sort of play civilians playing soldiers, as you can only do in peacetime. The film runs like this, from scene to scene and from fleeting image to fleeting image, stopping briefly in front of a window, at night, behind which a man holds a lamp and draws a curtain; or in front of children in a school playground, dancing in a circle free of any 'bogeyman'; or in front of those two men watching the sun go down whose military function we scarcely have time to discover since the sound of the waves has already given way to jubilant music that anticipates the ball sequence.

So what does the film do to testify to the historic mission of this nation of fighters? It presents what is extraordinary about their war as being exactly the same as what is ordinary about their peacetime life. The equivalent in images, if you like, of Pericles's funeral oration, the eternal

discourse of civilized Athens, in the face of warmongering Sparta: 'Our way of preparing ourselves for war is by living exactly as we please.' But what interests us here, more than the message, is the way it is constructed and the way this construction brings into play the Romantic principle of mixing genres. To bear witness to a confrontation in history, the filmmaker links together moments of rest or dream, as in a juxtaposition of under-motivated images. But those moments – a face and a light glimpsed behind a window, two men conversing in the setting sun, a song on a train, whirling dancers – have a very specific 'documentary' character. It is actually these a-significant moments that punctuate feature films. A piece of cinematographic fiction is a series of sequences moving towards a particular end – in the Aristotelian mode of linked actions – and of sequences that don't have a particular end but act like stases in the action, moments of rest or dream. Only, of course, these 'a-significant' moments have a very precise function: the thing that allows itself to be apprehended in them, within the suspended fiction, is simply the 'life' that the characters in the meaningful action are endowed with by the same

27

token. What is strange about Jennings's 'histori-
cal documentary' is that it is made up of a jux-
taposition of these stases from fiction, that it is
an attestation of reality constructed out of what
is real in fiction – the real that it attests and that
attests it in return. The expression that 'truth is
stranger than fiction' takes on its full meaning
here. Only fiction, through the necessity of its
sequentiality, is able to underscore the suspen-
sion of reasons that imposes truth–reality. The
documentary will only attain its human factual-
ity by imitating fiction, even beyond its logic. It
is the fictional play of the significant and the
a-significant, and its cinematographic applica-
tion to the play of the double gaze, that give the
image its documentary power. Cinema speaks of
history by doing an inventory of its means for
making a story, in the double play of reasons and
their suspension. The sheer enigma of a smile on
the face of the young Berlin shopgirl can thereby
turn into the watchfulness of the British coast-
guards, the equal watchfulness of the soliders on
leave and civilian volunteers, the collective show
of taking part in a shared fate that begins with
the equal power of all to interest both the eye of
an artist and the eye of a machine at the same

time. The ordinary life that is the stuff of absolutized art, the uninspiring subject who passively commands the light machine's recording and the nondescript historical agent who actively makes shared history are here made identical.

So, what prevents this nondescript subject from getting behind the camera and making history with it? Behind the window of an apartment block in Bucharest that is just like all the rest, a hand activated the camera that took a long shot of protesters marching on the presidential palace (*Videograms of a Revolution*). For some years, the Romanian government had encouraged the spread of these apparatuses, which were supposed to allow their compatriots to busy themselves quietly recording their small private pleasures. But this particular camera changed purpose and the images it shot match up with other images, taken behind other windows, to converge on this central point where the images of official television show us the Romanian Leader, the *Conducator*, haranguing his usual audience but being interrupted by the spectacle and dissonant noise coming from the far end of the square. In Bucharest, in that month of December 1989, Harun Farocki and Andrej Ujica

tell us, something unheard-of happened: cinema not only recorded the historic event but created that event. We might add that if cinema does actually create the event, this may well be because of its specific power to make historic any apparition behind any window whatsoever.

3 The threshold of the visible

But doesn't this mean accepting a little too conveniently the illusions of cinéma-vérité and history as offered in the images produced by the winners? The same Harun Farocki who showed us the historic power of the amateur filmmakers of Bucharest reminds us, in his other films, that, in spite of everything, the candid eye of the camera sees only what it is ordered to see. If the Allies didn't notice the concentration camps, despite the camps being perfectly 'visible' in the aerial photographs the Allies scanned for industrial installations to bomb, this is also because the cinematographic window of the visible is itself, to start with, a frame that excludes. Or rather, it is the threshold between what is, and

what is not, interesting to see (*Workers Leaving the Factory*). The first film ever made, *Workers Leaving the Lumière Factory*, all in all may well have determined, in forty-five seconds, the fate of cinema, defining the threshold of what it should or should not see. Cinema has never ceased replaying the same scenario. It waited for its characters – like the man in love with Marilyn in *Clash By Night* – at the factory gate. It has never been interested in what was said inside. It stepped inside only very briefly to film fake workers, gangsters who had come to steal the workers' pay. Against the backdrop of this original parcelling out of the visible and the invisible, the heard and the unheard, certain sequences of history stand out at the boundary between two spaces and two sets of meaning – scenes such as the Hamburg dockers' strike, for instance, as filmed by Pudovkin. In these scenes we see the imperturbable face of the picket watching the strike breaker buckling under his load while other strike breakers are already lined up behind the fence, waiting to take his place: emaciated and feverish faces glued to the bars of the fence in which we might already have recognized, Farocki tells us, the figure of the people shut

away in the camps that the Allied soldiers couldn't yet make out in 1944.

Does the revelatory power of the image, then, ever record anything other than the already given parcelling out of the visible and the invisible, the audible and the inaudible, being and non-being? In 1829, at the dawn of the socialist era, Pierre-Simon Ballanche rewrote the old story of the secession of the plebeians on the Aventine Hill, in the light of the then present day. Ballanche turned the episode into a conflict over the plebeians' visibility as speaking beings. Disarmed before these plebeians who persisted, against all the evidence, in granting themselves a right to speak they did not have, the patrician hit them with the ultimate argument: 'Your misfortune is that you don't exist and that misfortune is inescapable.' After a century and a half of struggles designed to prove such a contested existence, how can we not be gripped by what the Marxist Franco Fortini reads in his own book, on the sunny terrace where two other Marxists, Jean-Marie Straub and Danièle Huillet, have set up their camera? 'Basically, there is only one harsh and cruel breaking story: you are not where what decides your fate happens. You have no fate. You

do not have and you do not exist. In exchange for reality, you have been given a perfect outer show, a good semblance of a life.'

How are we to take those terrible words, which are addressed not only to the victims of the Nazi massacres, but to all the people who, like them, have endured a life decided by others, dispossessed as they have been of any personal capacity for making history (*Fortini/Cani*)? In 1992, Iossef Pasternak went to the Russian town of Efremov which, for Chekov, Turgenev and Tolstoy, symbolized the eternal somnolence of provincial Russia (*Phantom Efremov*). Coming out of the station, he found the same mud that the young Konstantin Paustovsky met with, in February 1917, when sent on an assignment by his newspaper. 'Funny sort of town', the young man said at the time to his coachman. 'There's nothing to see.' That earned this unanswerable question as a riposte: 'What on earth would you want to see?' That question-and-answer of days gone by is echoed, more recently, in the question-and-answer of young local journalists when asked about Efremov as communism was collapsing: 'Why explain Efremov to people who've never been there and will never go there?' What

can you show, after all, but the same toil and somnolence, brutality and cordiality, laziness and endurance that yesterday's writers have described a hundred times? At 10 Chekov Street, a man slices open a pig he has killed and cuts it up. 'Why do they twist words?' he asks, speaking of the mandarins in Moscow. '*I* never twist anything.' He was in Hungary, in 1956, in a tank. 'I'll never forget it', he says. But what won't he forget? The fact of having gone to a hostile country to risk his neck there or the oppression he went there to exercise? Or, quite simply, the equivalence of both the above, the fact that he had no more control of his fate than the Hungarians did theirs? The old saying goes that it's always in some remote place far away that the fate of the folks here is decided, a place way over yonder where no one answers 'guilty'. But doesn't he himself have the comeback that pins responsibility for his own fate squarely on him? 'Who among us is without sin?'

Is what we see a country without a history, men without a fate or unequal to their fate? Is that really what we're shown in the smile of the old peasant who joined the *kolkhoz*, the collective farm, the day it was set up, did ten years in

a gulag sawing tree trunks, and merely says, 'Here I live and that's all there is to it'? That smile makes us see that that's just it, life is both all and not all, at the same time. Don't we therefore need to refine Fortini's pronouncement and the Marxism of Straub and Huillet? What we are delivered in these faces marked with cold, work or suffering, and in these words that move between memories of the past and derision for the present, but always come back to a simple affirmation of life, is not just 'a good semblance of a life'. It is rather the exact equivalence of history and a lack of history. How can we say, when we see and hear these people who have been through the *kolkhozy* and the chemical factories of Efremov, the gulags of Siberia or military interventions in supposedly friendly countries, that they suffered their fate as if they were blind or backward? One day, we really should do away with the old line that goes that history's 'losers' lose because they can't understand, can't reason or talk – because they're too far away, too immured in their godforsaken bogs and their daily chores to understand the reasons for progress or for oppression. Listen, for instance, to the Sardinian miners filmed by

Daniele Segre (*Dynamite*). According to the official classifications, these men represent an archaic working class and an insular isolation. Yet it's impossible not to be gripped by their mastery of the language and the implacable lucidity with which they analyse the situation, arguing the case for their struggle and demolishing the official sophisms, but also retreating in the face of the very capacity they manifest and condemning themselves to suffer the false necessity whose ruses they demonstrate so perfectly.

In Efremov too, like anywhere else, people analyse their fate, and whether it is just or unjust; they analyse the part they played in their own fate and the part fate played without their help. They like to use fancy words, and know how to answer the interviewer's questions, and how to dodge them or turn them back on the interviewer. People share in the same power of language that divides life from itself, exceeds the 'all' of life and dooms life to fulfilling the declaration or promise contained in a few words. People both believe the words of the promise and do not believe them – and they do this not successively but simultaneously. And if you put your body to the task of confirming the bitter

words of Chekov or Turgenev, it's because you know those words and you want to show you know them. So much so that you no longer know whether Chekov, Turgenev or Gontcharov were right about the eternal nature of Russian life, doomed to being always the same, always the same as 'a good semblance of a life', or whether the very movement of that life, its way of being equal to the action and the suffering of history, is to imitate Russia's writers, to make life the same as the words of the masters of the language.

The suffering in these lives, then, is not due to words whose pointlessness, as everyone knows, is equalled only by their splendour. These people's suffering lies in seeing the pact speaking imposes go unacknowledged. Faced with the interviewer who wants to hear the old men and women reminiscing about the days of the Soviet Union, an old peasant woman digs her heels in and keeps repeating something no one is asking her to say, a thing she never stops saying without ever getting a reply, the only thing she's interested in: having her own little corner with a window. 'Why don't you answer? Why do you keep asking questions but you never give

answers?' The eye of the peasant sees true, people used to say in the days of Maoism. What the eye of the peasant woman of Efremov sees is this strange democracy that derives from a mechanical eye and ear that go everywhere, treat on an equal footing the light shining on the great and the small alike, offer a face, a voice and speech to the anonymous but never have to answer their questions. It is a pact of oppression between those who always ask the questions and those they question, to whom they 'give' a voice, without ever answering them in turn or considering them in all their equality as speaking beings.

It is here that the Marxism behind Fortini's words and Straub and Huillet's camera reasserts itself – though only if we distinguish it from the scientistic sociologism that holds that people suffer through ignorance and that relegation naturally carries that ignorance with it. Knowing that 'the class war is the last of the visible wars because it is the first in importance' (Fortini) is not thereby to measure ignorance and knowledge. It is to measure being and non-being. It is to question the visible about the way these things are parcelled out. The voice given by the camera

to the peasant women of Efremov, at the very moment when it shows their historic dignity, sends them back to their non-being. It inscribes what they say within the self-sameness of a landscape that is all flat plain, snow and *isbas*. The Romantic equality of the significant and the insignificant, the mute and the vocal, is an equality defined by the endless zero-sum exchange that gets the creases on a face or the cracks in the ground to talk, purposely muffling the voices and silencing the words. The show-and-tell machine gives vividness to every life only to take it back immediately for itself. To actively work as history, then, comes close to being an art that is conscious of its radical distance from what apes it – namely, the world machine that makes everything equally significant and insignificant, interesting and uninteresting; the information and communication machine that, in short, achieves the old sophistic equivalence of being and non-being. Where could non-being set itself up if everything is visible? The answer to that should be that it is precisely this indifferent visibility that sends almost all of humanity back to non-being or a lack of history: 'All of this hopes to persuade us of one thing only: that there is no

perspective, no scale of priorities. You must now get involved in this fictional passion as you have already done with other apparent passions. You must not have time to breathe. You must prepare yourself to forget everything – and fast. You must get ready to be nothing and to want nothing' (Fortini).

Fighting the nihilistic anaesthesia borne by the double play of the speaking image and the bestowed voice forces us, therefore, to suspend the double power of the image that speaks both through its sense and through its insignificance. It forces us to turn away from the evidence of these bodies that make their sufferings and their words shine at the same time, to separate the words from what they make us see, the images from what they say. Franco Fortini's argument – that the enthusiasm of the Italian intelligentsia of 1967 for the Israeli cause was fuelled by concealment of the Fascist past, by the concealment of the Fascist complicity in the extermination enterprise and by the burying of the victims on Italian soil – rolls on without the camera wielded by Jean-Marie Straub and Danièle Huillet running any documentary image of the Six Day War, any archival image of the massacres

of Marzabotto and Vinca in the autumn of 1944. There are no tortured bodies matching the writer's words, but the opposite – their absence, their invisibility. From the terrace where Fortini is rereading his text, wresting it once more from the silence of the written pages, the camera slips far away to explore the places where the massacres occurred. In those mute hills crushed by the sun and deserted villages, only the words of commemorative plaques remember, and say, without showing it, the blood that once stained these oblivious lands. Against tell-all Romantic poetics and the see-all information-world machine, we must pit the loneliness of the voice, its resonance alone confronting the mutism of the earth that says and shows nothing. Gilles Deleuze: 'It must be simultaneously maintained that speech creates the event, makes it rise up, and that the silent event is covered over by the earth. The event is always resistance, between what the speech-act seizes and what the earth buries. It is a cycle of sky and earth, of external light and underground fire, and even more of sound and the visual, which never re-forms into a whole, but each time constitutes the disjunction of the two images, at the same time as their new type of relationship,

a very precise relationship based on incommen-
surability, not the absence of a relationship'
(*Cinema 2: The Time-Image*).

No doubt we could question the filmmakers
and quibble with Deleuze, their interpreter, over
the exact gauging of this 'very precise relation-
ship'. What we are shown, though, more than
the brain screen or information table conceptu-
alized by Deleuze, is the interplay between the
search for such a relationship and its anticipa-
tion. Something, in short, that recalls the echo,
the musical *Anklang*, that, for Hegel, character-
izes symbolic art – either the beginning of art,
where the meaning is still searching for a percep-
tible form, or the ending, where it knows that
no perceptible form will ever correspond to it,
that all forms are equally available and inessen-
tial. For Hegel, as you will recall, the sheer reso-
nance of music takes over from the capacity of
pictures to show all. And the fate of cinema, and
of its relationship to the common fate of history,
could stand between two ideas of music: the
well-orchestrated symphony of images that, for
Canudo, Epstein or Vertov, was meant to take
the place of the old language of words, and the
distant call of words to images that currently

characterizes its most acute forms. If the great utopia of cinema, in the days of the October Revolution of Russia and of the modernisms of Europe, involved replacing the stories and characters of the old world with the new man, authentically captured by the camera's guileless eye, and if the banality of the talkies killed that dream, the third stage of cinema's will to art, as well as of its sense of history, would surely involve reversing the original relationship and making images the appropriate medium for making words heard, wresting them from the silence of texts and the lure of bodies that claim to personify them. If there is a visible hidden beneath the invisible, it's not the electric arc that will reveal it, save it from non-being, but the mise en scène of words, the moment of dialogue between the voice that makes those words ring out and the silence of images that show the absence of what the words say.

4 In the face of disappearance

And so we are back to our initial concern: what can history do, what can the cinematographic image do, what can they do together in the face of the revisionist will and determination to deny what was, to pretend it never happened? The German word for the extreme form of that will, as we know, is *Vernichtung*, which means reduction to nothing, annihilation, but also annihilation of that annihilation, the disappearance of its traces, the disappearance of its very name. What is specific to the Nazi extermination of the Jews of Europe was the rigorous planning of both the extermination and its invisibility. It is the challenge of this nothingness that history and art need to take up together: revealing the process

by which disappearance is produced, right down to its own disappearance. We know that Holocaust denial has two possibilities, one of which is not seeing what is, in fact, no longer visible, the other of which is making so much of the context of the event that the specificity of this disappearance disappears. There is the shameful Holocaust denial that says that it simply did not take place. And there is the 'honest' Holocaust denial that invokes science's vocation not just to observe but to explain. What reasons, the 'honest' revisionist asks, did the Nazis have to exterminate the Jews? All sorts of answers to that question present themselves. The first is that the Nazis had no such objectives, from which it is tacitly deduced that an event that has no reason for being may well have no being; the second is that they lost their reason because they were fanaticized, which, it is implied, easily happens with crowds, especially when they are hungry and humiliated, because crowds are pretty primal and love leaders, and because it is the condition of human beings in general to be cast out into the world too early, in a state of dependence and fear that leaves them open to every death-dealing fantasy – to the fantasy, for instance, of a failed

artist whose mother was treated badly by a Jewish doctor; the third answer is that the Germany of those years was confronting a real threat, the threat of communism, many of whose representatives were Jewish, whence the construction of the 'Judeo-Bolshevik' enemy whereby the real adversary was the Bolshevik, and the annihilated Jew simply the substitute to hand. It is deduced from this that the victim was simply in the wrong place at the wrong time, through sheer bad luck, and paid the price in someone else's place. It could be further deduced that the price paid was heavy but that, in any event, the real culprit was the Russian Revolution, which forced the Nazis into such horrors because it was itself a contagious horror.

Showing the annihilation, as Claude Lanzmann does in *Shoah*, therefore implies that you have linked a theory about history with a theory about art. The theory about history is borrowed from Raul Hilberg and is simple: the history of the destruction of the Jews of Europe is an autonomous history that derives from its own logic and doesn't need to be explained by any context. 'The missionaries of Christianity had in effect said: you have no right to live among

us as Jews. The secular leaders who followed suit had proclaimed: you have no right to live among us. The German Nazis in the end decreed: you have no right to live.' From this is deduced the pointlessness of the endless archival images that show us people out of work and starving, battling each other for soup as it is being ladled out in soup kitchens on the streets, and all those campfires that turn into autos-da-fé and all those parades of fanaticized blond heads. Between those images and the fact of annihilation, there will never be any constructible storyline other than that of a history of times past, a history of the time when capitalism was afraid of communism and was not able to control its own crises, either; a time when young people believed in ideals to the point of sacrificing their lives for them and, more to the point, the lives of others. A story from before the war.

From this the conclusion is sometimes too easily drawn that the extermination is 'unrepresentable' or 'unshowable' – notions in which various heterogeneous arguments conveniently merge: the joint incapacity of real documents and fictional imitations to reflect the horror experienced; the ethical indecency of representing

that horror; the modern dignity of art which is beyond representation and the indignity of art as an endeavour after Auschwitz. But writer-witnesses have already been able to find words that match the horror. And, naturally, any mimetic image will fall short of what words can convey. Yet, contrary to what the information machine believes and would have us believe, aesthetics has already known for a long time that images will never reveal as much as words when it comes to anything of any magnitude that oversteps the mark: horror, glory, sublimeness, ecstasy. So it's not a matter of picturing the horror but of showing something that precisely has no 'natural' image – inhumanity, the process of negating humanity. This is where images can 'assist' words, can make heard, in the present, the present and timeless sense of what they say, can construct the visibility of a space where that is audible.

So we have to revise Adorno's famous phrase, according to which art is impossible after Auschwitz. The reverse is true: after Auschwitz, to show Auschwitz, art is the only thing possible, because art always entails the presence of an absence; because it is the very job of art to reveal

something that is invisible, through the controlled power of words and images, connected or unconnected; because art alone thereby makes the inhuman perceptible, felt. Alain Resnais had already contrasted photographs of survivors and corpses taken when the camps were opened up with the mutism and indifference of the surrounding natural environment (*Night and Fog*). Claude Lanzmann radicalizes this approach by excluding any archives and by confronting minutely detailed accounts of the annihilation – which can only be told, but which also needs to be told in such detail, weighed down as it is by the will to forget – with landscapes that have erased all traces of it. That is to say, with the simple inhumanity of soil and stones. And since it is a matter of art more than anything else, the issue is not one of ruling out any kind of representation, but of knowing which modes of figuration are possible and what place direct mimesis can have among them. This is why Claude Lanzmann has not represented any spectacle of horror, but instead got his witnesses to make certain gestures that precisely mark the process of human beings becoming inhuman: he asked the barber to mime the final shearing;

the then-adolescent 'worker Jew' to sing the nostalgic song the executioners liked, getting him to stand in a small boat similar to one back then; the driver to drive a locomotive similar to the one that unloaded its cargo of men and women ready for gassing. The former SS camp warden himself recalls the work song the inmates were made to sing in Treblinka. It is precisely a matter of reproducing these gestures and songs as they were, made or sung by men who are the same but also not who they were – that being the point. It is a matter of wresting them away from any simulacrum of a 'specific' body, place and time that would only bury them, and of placing them instead in the intemporality of their present. It is a matter of reserving for the rigour of art the power of representation, which is the power of the *muthos* appropriate for inscribing the annihilation in our present.

Arnaud des Pallières was born well after the round-up of the 'Vél'd'Hiv', the winter velodrome, and the establishment of the camp at Drancy, which he has known only in its 'current' guise as the 'Cité de la Muette', the camp having been restored, after the war, to its initial function as affordable housing. No survivor comes to bear

witness in front of the camera in *Drancy Avenir* (the joint name of a tram station and of another idea of time, one that goes from the future back to the past). Eyewitness accounts of the round-up, of the Drancy camp and the camps for which its internees were destined are, in the film, what they are for us – texts. This is why their fictionalization is even more of an issue. By fictionalization let it be clear we mean the apparatus of their sequential arrangement, of the voice that utters them, the body behind that voice, and the images that correspond to them. The fiction in *Drancy Avenir* is constructed in exemplary fashion as the very construction of the link between an idea of history and a certain power of art. This assumes nothing less than the sequential linking of three levels of fiction. At the first level lies the 'realist' fiction of a history lesson, in which a historian has someone read out to his students eyewitness accounts of deportees and then inscribes the words read in the Benjaminian battle between two histories: the cumulative history of the winners which, in a single move, pursues its 'triumphs' and consigns the memory of them to the past; and the messianic power that can make an authentic image of the past shine in the present

instant in order to ignite a spark of hope, at the very heart of past events. The teacher's 'realist' fiction, which is the only time a body is given to the voice reciting, is connected to the quasi-fiction of the student on a memory quest. I say quasi-fiction because all the student does is lend her voice (*off*) to the words of the texts, and her ambling body to the movement that guides those words about the inhumanity experienced towards images of humanity that manage to inscribe a trace of that inhumanity. So the story of the 'little girl from the Vél'd'Hiv' is accompanied by the research student to the grounds where the arrest took place, then driven further to the quite simple images of an apartment empty of its signs of life, to the strains of a Romantic German lullaby which enjoins children to sleep in peace, countersigned in the present by the implacable gaze of a little girl sitting on the terrace outside a café. The account of how the camp was organized is accompanied by long panoramic shots of the city walls and shots of employees sitting at their computers; the night-time roll-call of the children, and by high-angle shots of city children playing in snow like the snow in Brueghel's *Massacre of the Innocents*.

The images give the words an analogous space where their presence is made felt, they confer on the inhumanity of the extermination its only acceptable equivalent, the inhumanity of beauty.

The quasi-fiction of the student is thereby in turn inscribed within a fiction about the work of memory as it extends across three works. The first, the fiction of the victim, is represented by a saved fragment of Orson Welles's *Merchant of Venice*: this is the only body the film gives the Jews, but also, perhaps, an echo of the history of cinema and of the century evoked by Godard, the history of 'all the films that never were', all the films that, like the internees of Drancy, have been denied the chance of living. The second work, the fiction of dehumanization, has been borrowed from the Conrad of 'Heart of Darkness' and follows the path of the boat as it goes up the river to the point where the conquering civilization and the savagery it came to instruct have become indistinguishable. The third work, the fiction of constancy, is incarnated by an aria of Mozart's, 'Come scoglio' ('Like a Rock'), from *Cosi fan tutte* which the absolutely fictional character of a daughter of deportees is rehearsing in Berlin, inhabited as she is by an indestructible

faithfulness, beyond all sorrow and all recollection, to the duty of singing and a passion for German song. Fiordiligi's constancy, we know, won't hold out till nightfall. But the constancy of song will. And, in the face of silence, trivialization or the temptation of the unutterable, the work of art asserts its unique power of remembering.

The constancy of art will then go against the philosopher's maxim that maintains that *whereof one cannot speak, thereof one must be silent*. That maxim of Wittgenstein's was meant to be critical but, today, chimes a bit too neatly with the maxim of 'realist' governments that identify their brand of conservatism with the harsh law of a reality subject to the sole necessity of what is possible, and with the intellectual nihilism of the notion of the end of history or of ideologies. The reality of the twentieth century, in its most extreme harshness, is something fiction can bear witness to. Provided, of course, that we separate the power of fiction from the mere construction of the anecdote portraying individual loves and sorrows against a backdrop of collective grand passions and grand catastrophes. At the end of the nineteenth century,

Mallarmé opposed the derisory stage that simply offered the ladies and gentlemen of the audience their counterfeits, and tried to tease out the new power of a form of fiction no longer linked to belief in the existence of a character, but to the 'special power of illusion' proper to each art. There was a time, in the 1920s, when the 'power of illusion' of cinema, the conjunction of the eye that records and the eye that draws, of machinic radiography and symphonic montage, was viewed as defining a supreme art, one that buried the stale old notions of psychological man and representational fiction, and was up to speed with manufacturing man and the new collective. Today, cinema's capacity to make history seems more closely connected to another way of fictionalizing: one that inquires into the history of the century through the history of cinema and *that* history through the issue of the kind of history that the signs of art organize. Jean-Luc Godard, in *Germany Year 90 Nine Zero*, and in the *Histoire(s) du cinéma*, thereby questions the century through a dialogue between the Leninist dream factory and the Hollywood dream factory; the images of escheated socialist Germany and capitalist Germany through a phrase of Rilke's,

reference to Goethe, the music of Bach and Beethoven, but also the silent music of the gramophone in *People on Sunday* or of Siegfried's death in Lang's *Nibelungen*, the statue and the verse of the Sovietized Pushkin or the image of Don Quixote overtaking, in his 'utopian' stampede, the broken-down Trabant, that automobile of 'real socialism' made in East Germany. Elsewhere, in the shadow of one of Giotto's angels, he questions the relationship that may well link Elizabeth Taylor's 'place in the sun', as she performs a film version of Dreiser's *American Tragedy*, to what director George Stevens was able to see when the Nazi camps were opened up. If history doesn't show itself without the construction of some kind of heterogeneous fiction, that is because it is itself made up of heterogeneous tenses, of anachronisms.

Part 2

SENSES AND FIGURES OF HISTORY

1 Of four senses of history

1.1 History, the word 'history', has several meanings. Let's focus on four of them, which can be combined in various ways. History is first an anthology of what is worthy of being memorialized. Not necessarily what *was*, and what witnesses testify to, but what deserves to be focused on, meditated upon, imitated, because of its greatness. Legends offer such a brand of history as much as chronicles do, and Homer more than Thucydides. No matter what has been claimed, it is not events that lie at the heart of this kind of history, but examples. History painting does not mean the clash of battles or the lustre of courts, but the old soldier confronted by Belisarius and his begging bowl, Mucius Scaevola

thrusting his hands into the fire and holding them there, Brutus meditating in a corner of the canvas while the stretchers bearing the bodies of his sons only half-appear in the background. Examples of fortune and misfortune, of virtue and vice. Not that far removed, in a sense, from the concern of the new history with moments and gestures that signal a way of occupying a world. Only, memorial-history doesn't propose reading the sense of a world through that world's signs. It proposes examples to imitate. This supposes a continuity between the scene that is worthy of being imitated and the act of imitating in its double sense: the work of the painter and the lesson drawn by the involved spectator. If that chain is broken, the memorial function of history is cancelled. Those who tell us to look closely at representations of the abominations of the twentieth century and to meditate carefully upon their underlying causes so we avoid repeating them forget one thing: the times of memory-history are not the same as those of truth-history. Whence the strange reversal whereby, in our day, the memorial is more and more like an empty temple of what is meant to remain unrepresented.

1.2 History secondly means a story. In a painting, a specific moment, significant for the action, commands attention. The movements of the characters converge on this central point or reflect its effect right to the outer edges of the scene. Eyes stare at it, outstretched arms direct us to it, faces broadcast its emotion, mimed conversations comment on its significance. In short, the painting itself is a story – that is, an arrangement of actions, a meaningful fable endowed with appropriate means of expression. Aristotle contrasted the general run of poetry, with its necessary or plausible linkings of causes and effects, to the contingency of the narrative account that tells us precisely that this event followed that. But, ever since Polybius and Titus Livius, the narrative account of events has also been constituted as a presentation of the necessary and the exemplary. Since the Renaissance, painting has proved that it was 'like poetry'. And 'history painting' is, par excellence, the kind of painting endowed with a capacity to condense the poetic fable's power as generality and example in the representation of a privileged instant. The *story* that the composition of parts and the disposition of forms over the

canvas constructs asserts its exact coincidence with the memorial and exemplary function of history.

But this concordance between history and story also spells their potential dissociation, when the expressive composition of the canvas asserts itself at the expense of the scale of the representation's grandeur. Diderot stressed this dissocation in his *Salon of 1769*. Jean-Baptiste Greuze, the painter who could make an example of any domestic scene, making people's bodies and gazes stretch out towards the dying father, the prodigal son or the well-behaved wife, no longer had any idea how to give Caracalla the grandeur that a Roman emperor, no matter how villainous he may have been, should manifest in his attitude. History as an exemplary composition of expressive means and history as an anthology of great examples thereby part ways, twenty years before the revolutionaries of France volunteered to revive the glorious examples of the Roman chronicle. But the failure of the genre painter to rise to history painting also heralds a time when it is genre painting, the representation of nondescript lives, that will be the

exemplary manifestation of historicity. And the very play of the junction and disjunction of *exemplum* and *historia* will, in the twentieth century, allow painting to play around with its ideological programmes. Greuze's inability to represent history in all its majesty will be met with the ability of this or that Fascist or Soviet painter to serve his cause by concentrating exclusively on the composition of volumes and the distribution of light. This is what Alexander Deineka does in his *Kholkozian Woman on a Red Bicycle*, the vibrancy of which absorbs any colour symbolism; it's what he does in his *Future Pilots*, where the boys are represented from behind, facing the aeronautical epic that the oldest boy's arm points to, but where the interest is wholly centred on the boys' bare backs, while the seaplanes, in front of them, turn into birds in a surrealist landscape. 'What I like', the painter said simply, 'is man making expansive gestures'. Symmetrically, the political value given to the monumentality of the forms and the very static nature of the composition allows Mario Sironi these strange official representations of workers devoid of any swaggering intensity, such as we

see in *Work in the Country*, which provides only a dead tree as a set for the work of an obscure digger.

1.3 In the meantime, a third type of history was to secure its dominion by destroying the harmony between the expressive disposition of bodies over a canvas and the effect of an exemplary grandeur communicated by the scene. This is History as an ontological power in which any 'story' – any represented example and any linked action – finds itself included. History as a specific mode of time, a way in which time itself is made the principle behind sequences of events and their significance. History as movement directed towards achievement of some kind, defining conditions and tasks of the moment and promises of the future, but also threats for anyone who gets the sequence of conditions and promises wrong; like the common destiny that men make for themselves but that they only make to a certain extent, since it constantly eludes them and its promises are constantly reversed as catastrophes. If this particular form of history defeats the well-ordered play of the exemplary figure and the expressive composition, this is nonetheless not because it is marked,

as some would have it, by an inherent stamp of terror and death. It is more simply that, as a matter of principle, no action or figure can ever be adequate to the sense of its movement. The distinctive feature of this form of History is that none of its scenes or figures is ever equal to it. Take the character, in Goya's canvas, *The Third of May* (*El Tres de Mayo*), whose arms form a cross and who, alone, faces things, but also cries for no one, caught as he is between two masses of anonymous bodies that rule out his gesture's having any impact and his words' having any echo: at his feet lies a heap of executed men crushed against the ground; facing him stand the compact group of executioners, represented from behind, their faces erased in the curve that runs from bag to gun. It's not just a figuration of 'the horrors of war'– till then reserved for the minor genre of engraving – that grips the canvas. It is above all a reversal of the tradition of the history painting: the disposition of bodies no longer makes sense except by stopping making *historia*, simulating the negation of any *dispositio* deriving from some kind of artistic power. History is no longer an anthology of examples. It is the power that steals bodies from the virtuous uses of story

and example. From now on, history flags itself through the sheer excess of what *was* over any meaning. This does not mean, though, that the unrepresentable now lays down the law. This kind of History no longer attests to itself in the composition of attitudes and the exemplarity of figures. It attests to itself in the analogy shaped from it by its insubstantial characters, who seem to arise from the lines and brushstrokes and the pictorial material, ready to be swept up again by the power that pulled them out of the chaos of coloured materials. In any coloured mass, there is from now on a virtual body and a sense of history. All that is needed is, say, this red or blue trickle that makes the figure of the hostage emerge from Jean Fautrier's thick paint.

1.4 But this reversal doesn't exhaust the future of history painting, because it doesn't exhaust the sense of the word 'history'. History with a capital H is not just the power of sense to exceed action which is turned upside-down as a demonstration of non-sense, referring form to the material from which it emerges and to the gesture that pulls it from that material. History is not just the saturnine power that devours all

individuality. It is also the new fabric in which each and every person's perceptions and sensations are captured. Historical time is not just the time of great collective destinies. It is the time where anyone and anything at all make history and bear witness to history. The wax masks of the men gunned down in Goya's *Third of May* correspond to the pink of the milkmaid's cheeks in his *Milkmaid of Bordeaux* (*La lechera de Burdeos*). The time of the promise of emancipation is also the time when any skin proves capable of manifesting the radiance of the sun, and any body is allowed to enjoy that sun in its own time and to bring out that enjoyment as a testimony to history. Hegel had already celebrated the way in which, in Dutch genre painting, a scene at an inn or the representation of a bourgeois interior was marked by history. But in the time of History, genre painting abandons interiors, shops and inns, and invades the meadows and forests, rivers and ponds reserved for the heroes of myth. And at the juncture of the genre painting and the mythological landscape, in the sunshine of Renoir's or Monet's *Grenouillère* (*Frogpond*) or the shadows

of Seurat's *Grande Jatte*, another form of history painting asserts itself. In it, history puts itself on show, matter-of-factly, wonderfully, as the raw material in which light plays on the water and games of seduction play out on river banks, in canoes or on sunny terraces, as the living principle of the equality of every subject under the sun.

2 History and representation: three poetics of modernity

Anthology of examples; arrangement of fables; historial power of necessary, common destiny; historicized fabric of the sensible. Four different types of 'history', at least, come together or come apart, contrast or interlace, variously reshaping the relationships between pictorial genres and the powers of figuration. It is indeed too simple to lump two movements together: the one that wrests art away from representation and the one that turns History into a devastating power that finds its completion in the camps of the twentieth century. Encouraged by a hasty remark of Adorno's, the unrepresentable horror of the camps and the anti-representational rigour of modern art have too readily celebrated retrospective

marriages. Showing 'what cannot be seen' would be impossible and unjustifiable. But the inference drawn from this is false. 'No se puede mirar', writes Goya on one of his drawings. But that doesn't stop him getting down a vision of what he says can't be shown. It is the particularity of painting to see and make seen what won't let itself be seen. A century and a half after Goya, the Slovenian painter Zoran Music will similarly devote himself to reconstructing Dachau's corpse-filled fields as 'slabs of white snow' or 'silver reflections over the mountains'. Resisting the camp's fate to erase and silence means not only inscribing the traces of the horror as a faithful witness. It also means obeying the artist's duty, which orders the eye and hand 'not to betray these diminished forms'. It means being faithful to the general task that art – figurative or otherwise – prescribed for itself once it stopped being subject to the norms of representation: showing what can't be seen, what lies beneath the visible, an invisible that is simply what ensures that the visible exists.

So the relationship needs to be nuanced. Of course it's true that History, in its sense as a fate-dealing power, arises at a time when the classical

representational edifice was crumbling. That edifice had kept all representation under the rule of the *ut poesis pictura* –in other words, under the rule of a poetics that defined the relationships between two different types of history (*histoire*) – one a history, one a story; between the exemplary value of subjects and the appropriate forms of their *dispositio*. But the opposite of the representational system is not the unrepresentable. The system is not, in fact, based on the sole imperative to imitate and make the image like the model. It is based on two fundamental propositions. One defines the relationships between what is represented and the forms its representation takes; the other defines the relationship between those forms and the material in which they are executed. The first rule is one of differentiation: a specific style and form are suited to a given subject – the noble style of tragedy, the epic or history painting for kings, the familiar colour of comedy or of genre painting for the little people. The second rule, on the contrary, is one of in-difference: the general laws of representation apply equally no matter what the material medium used in the representation, whether it be language, painted canvas or sculpted stone.

The two rules are interdependent. The age in which the arrangements of the *exemplum* and the *historia* are overturned by the new 'history' that men make without making it also underscores, with Burke, Diderot and Lessing, the irreducible heterogeneity of the means of expression that every kind of material offers. But we are too quick to conclude from this that the age of History is the age of the sublime impresentation, presenting the unpresentable, of the indefinitely restaged gap between the idea and any medium. Rather, the poetics of the historical age, in reversing the two rules of representation, multiplies the possibilities of figuration, the relationships possible between the subject, its form and its material. On the one hand, the subject is indifferent, it doesn't prescribe any particular form. All those represented are equal in dignity, and the power of the work resides entirely in style as 'an absolute way of seeing things' (Flaubert), in the way the artist imposes a manner, the appearance of a world (*un apparaître de monde*) on his material, no matter what the subject. On the other hand, the material used is not indifferent. The texture of the language or the pictorial

74

pigment belong to a history of matter in which all matter is a potentiality of form.

On that basis we can define the three great poetics that the age of History has pitted against the canons of representation and that were formulated in the literature and thinking about literature of the twentieth century, before being figured in the century's pictorial works and manifestos. These three ways of identifying the power of the work with a power of history overlap variously with the four kinds of history we have tried to isolate and are themselves liable to overlap in their principles and their effects. We will try here to describe these poetics, independently of the specific 'schools' they have come to be embodied in and the monopolies over particular names or concepts those schools have laid claim to.

2.1 The first poetics, which we might call *abstract symbolist*, deals the most radically with the collapse of the representational world as a whole and settles on art the historic task of replacing that world with an equivalent order: an order that produces a system of actions equivalent to the old order of *mimesis* and plays a role in the community equivalent to the banished

vanities of representation. It contrasts the imita-
tion of things or beings with the exact expression
of the relationships that link them, and with the
outline of the 'rhythms of the idea' that are able
to serve as a foundation for a new ritual, sealing
the duty that links the 'multiple action' of
men. These terms of the poetics and politics
proper to Mallarmean 'restrained action' are
found expressed, conceptually and plastically, in
abstract art, from Kandinsky to Barnett Newman.

2.2 The second poetics is quite specifically
dedicated to revoking the principle of the in-
difference of matter. It identifies the power of
the work of art and of history as a bringing to
light of the capacity for form and idea immanent
in all matter. This poetics of nature, as 'uncon-
scious poem' (Schelling), locates the work of
art within the continuous movement by which
matter already takes form, sketches its own idea
in the folds of the mineral or the prints of the
fossil and rises to ever higher forms of self-
expression and self-symbolization. Let's agree to
call this poetics, whose features are set out in the
theoretical texts of Auguste Schlegel and the
'naturalist' works of Michelet, *expressionist sym-
bolist*. Those terms don't so much define the

features of the schools of the same name as the pictorial possibilities running through the various schools and genres. It might be the way the 'subject' specific to the work emerges from the thick pictorial matter in Asger Jorn's 'political' painting *Homage to the Rosenbergs*, or the way it melts into it in the 'apolitical' canvases of Action Painting. It might be the de-figuration Otto Dix uses to express the truth about a war, inscribing living bodies, piles of dead bodies and inert matter in the muddy continuity of the same decomposition. But, above all, this poetics establishes one of the main processes by means of which the art of the twentieth century was to 'catch up with history' – namely, the play of metamorphoses through which what is represented, matter and form, change places and exchange their powers.

2.3 The third poetics emphasizes the destruction of the relationship between form and subject. It not only plays on the equality of all those represented but, more broadly, on the multiple forms that the de-subordination of figures to the hierarchy of subjects and dispositions may take. The Flaubertian principle, 'Yvetot is just as good as Constantinople', doesn't simply say that

a small subject is just as good as a great one, if all that counts is the artist's style. It says, more profoundly, that you can always make Constantinople appear in a representation of Yvetot, the infinite emptiness of the desert of the Orient in a damp, cramped room in a farmhouse in Normandy. Let's agree to call this poetics *(sur)realist* to indicate the following: 'realism' is not a return to the triviality of real things as opposed to the conventions of representation. It is the total system of possible variations of the indicators and values of reality, of forms of connecting and disconnecting figures and stories that their destruction makes possible. The fantastic turn that the documentary 'coldness' of the new objectivity has taken, its *devenir-fantastique*, when transplanted to Dutch soil, has been called 'magic realism'. But realism and magic have been in league from the outset. When Carel Willinck puts his solitary figures in evening dress and plants them in the cardboard ruins of Pompei, all he does is turn around Flaubert's initial gesture, transposing the antique Oriental fresco of *The Temptation of Saint Anthony* into scenes of contemporary mores. And the elimination of the line between dream and reality is

in itself merely one particular transformation among others in the set of de-figurations and re-figurations that define realism as being always inhabited by *(sur)realism*.

The age of History, then, is not the age of a kind of painting that is driven by world catastrophe, and by its own movement, towards rarefaction and aphasia. It is rather the age of the proliferation of senses of history and the metamorphoses that allow the interplay of these to be staged. Let's go back to the celebrated text in which Kurt Schwitters describes the foundation of *Merz* just after the Great War: 'I had to shout my joy throughout the world. To do so, I took what I found, for reasons of economy, as we were a nation that had fallen on hard times. You can also shout by using rubbish and that's what I did, glueing and nailing [. . .]. In any case, everything had broken down and new things had to be made out of the fragments.'

The exceptional historical situation that leaves only fragments of the past and the rubbish of daily life to forge a hymn to the future is every bit as much an opportunity to join together the three poetics of modernity in a single radicality, putting the building of relationships in the

place of the reproduction of things – using not only the equality of all represented, but also the capacity of all matter to become form and subject. Bric-a-brac from attics and dustbins can take the place of the painter's colours in an 'abstract' kind of painting that immediately becomes history painting – as radicalized genre painting. In it, ordinary life is represented – that is, supplanted – by its materials themselves, by the detritus that gives it its concrete texture. But the tram ticket, box lid or newspaper cutting stuck on the canvas are not only 'traces of history'. They are metamorphic elements equally capable of being subjects, forms or materials. If every object immediately has the potential to become subject, form or material, this is not only, as has sometimes been suggested a bit too hastily in the age of Pop, because of its 'documentary' value, which turns it into a vehicle of a critical function. It is because, in the age of history, every object leads a double life, holds a potential for historicity that is at the very heart of its nature as an ordinary perceptual object. History as the sensible fabric of things is doubled by history as fate-dealing power. Freeing history-as-example and (hi)story-as-composition from

their subjection to representation, it multiplies the figurative possibilities which all forms of de-figuration then enjoy. And this multiplication supports the various forms of historicization of art, making *compossible*, or co-existent, two 'fates for art': the constructivist-unanimist project of 'transforming the whole world into one gigantic work of art' (Schwitters), but also its apparent opposite – the critical project of an art that elim-inates its own lie in order to speak truthfully about the lie and the violence of the society that produces it. The completion and self-elimination of art go together, because it is the very particularity of history as a fate-dealing power that, in it, any existing form aims for a completion that is identical to its own elimina-tion. And the age of History also confers upon all formless matter, just as it does on all estab-lished writing, the possibility of being turned into an element in the play of forms. The age of the anti-representation is not the age of the unrepresentable. It is the age of high realism.

3 On three forms of history painting

3.1 Based on what we've just established, without any claim to exhaustivity, we may define three main ways in which the art of the twentieth century was able to face up to history – combining the various kinds of history and their pictorial or plastic possibilities. The first is the analogical manner. This makes a certain sense of history, of the job it imposes on artists and of the subjects it offers, coincide with the movement specific to the arrangement of pictorial elements. It is, then, a symbolic art in that it suggests an *analogon* for history and identifies this *analogon* with the presentation of art by itself, of the movement that translates an idea

into coloured forms or makes a figure emerge from the pictorial material.

But symbolism itself takes two different forms. In one, the symbol is a sign that takes shape and makes sense through a ritual; in the other, the symbol is a detached part of a whole, a static moment in a movement that both presents and signifies this movement at the same time. Abstract or expressionist symbolism, we called it. On the first side, we would find the 'Mallarmean' logic of someone like Barnett Newman. After the two world wars, Newman tells us, painters can no longer paint flowers, reclining nudes or cellists, as if nothing had happened. But nor can they just play around with meaningless forms because that would mean consenting to America's chaotic reorganization of the world. What remained was to conceive of the canvas as the organization of ideas into plastic elements that are also elements in a religious ritual. The black stripe against a grey background of *Abraham* or the red stripe against a brown background of *Achilles*, those 'channels of spiritual tension', stand up to the chaos of the world wars or of simple American anarchy, creating a spacing of ideas on the canvas that is analogous to the spacing of the Mallarmean page.

Symbolism, on the other hand, takes its expressionist form in Jean Fautrier's *Hostage* (*Otages*) series, in which the hostage represented is just as much a hostage to the power of pictorial presentation, visible in, say, an indecisive line of colour tracing the curve between a nose and a mouth, and multiplying or subtracting eyes around this central line, going from the regular oval of an egg to the chopped-up line that circles round the chalky impasto of the *Man Shot* (*Fusillé*), which no longer recalls any human form but looks more like a *Landscape* from 1944. These plays on de-figuration inscribe painting as a 'subject of history' within the great *mimesis* whereby the movement of pictorial matter towards expression imitates the movement of living matter taking shape, the imprint of the fern fossilized in stone or the return of the mortal animal to the mineral. Alfred Manessier's 'political' paintings would no doubt stand somewhere between these two kinds of symbolism. In those paintings, a host of small regular luminous splotches of colour are spread in rows over a dark background, at will, figuring the spiritual tension of an abstract homage to the soldier priest Helder

Camarra, or sketching the teeming *favelas* of his homeland.

3.2 A second manner in which art stands up to history is opposed to this construction of symbols or *analoga* of history. This second manner operates on another kind of metamorphosis, the kind that usually turns images into signs and signs into images, in the general run of things in our world. This style of art could be described as *mythological*, in Barthes's sense of the word. It plays on the *sham* nature of any image of History, as well as on the historic nature of any reproduction of any state of things whatever. It plays, in short, on the constant cross-referencing between history on a grand scale, with its portraits and its emblems and speeches, and small-scale history, with its displays of merchandise, or of detritus, its family portraits or the public displaying of its fantasies and fetishes; on the equivalance, in the final instance, between a generalized historicization and 'the end of history'. The proliferation of images–signs generated by commerce and the State provides this manner of art with an infinite repertoire of *exempla* whose duplicity is meant to be revealed

by a specific *dispositio*, or portrayal: the image that is a sign or the sign that is an image; political majesty that is a mercantile lie or the mercantile display that is a political lie; the extraordinary that is ordinary or the banal that is fabulous. Its repertoire consists of official images of the great and the good of this world or auratic portraits of its idols, snapshots of history captured by the camera, images of daily life that resemble the posters and fantasies that sell merchandise, emblems of power or images of history that are now indifferent signs or recycled objects.

Restoring every *exemplum* to its banality as an image and as an ordinary object, elevating every banal image to the power of an example; duplicating an image so it avows its duplicity, turning it round to show its other side – these are the essential weapons of this manner of standing up to history. It finds its primary motor in the collages of Dada and its logical conclusion in the multiple forms and derivations of Pop Art as a critique of the image that is coextensive to its reign. It involves all the work on variations and combinations of images – reproductions, icons, idols – trivializing multiple images of governors or stars (Andy Warhol); transporting official

images of the young Mao to the Piazza San
Marco in Venice (Erro); combining a portrait of
Miss America 1968 with a snapshot of a Viet-
namese prisoner of war being beaten up (Wolf
Vostell); further mummifying the mummified
portrait of Brezhnev (Erik Boulatov). It also
involves all the work on emblems of history: the
red horizon – red carpet of the same Boulatov;
the American flag painted–unpainted by Jasper
Johns; emblems of the French Revolution
reduced by Sigma Polke to articles publicizing
the Bicentenary; the history painting perverted
by Larry Rivers, pointing up the iconic weirdness
of *Washington Crossing the Delaware* through the
play of blocked perspectives. The same Larry
Rivers turns the photographic trivialization
of *The Last Civil War Veteran* on its head by
repainting it using crude colours and bizarre
perspectives; and he ressurects the value of for-
gotten history in the icon of a Napoleon on a
banknote, or the golden age of Dutch painting
in the image of Rembrandt's *Drapers' Guild* that
serves as an emblem for a brand of cigars. After
this, come various treatments of the advertising
or political poster: the light scuffing with which
Mimmo Rotella restages images of the reign of

merchandise or legendary stars; the play of superimposed images by which Jacques Villéglé hollows out the images and messages of an electoral campaign; the dilaceration that, in Raymond Hains, reduces images and signs to the dispersal of coloured fragments exposing the canvas support. This iconic play is continued in written messages: Morris's half-erased pages of newspaper; or Adrian Piper's newspaper pages overloaded with the heads of black people in the *Vanilla Nightmares* series; Polke's enlarged letters or Boulatov's monumentalized letters printed over the official images of the unanimous Central Committee or the Soviet cosmos. It is, in short, the re-exhibition of painting by itself. Equipo Cronica's painting accordingly stages the *Visit to Guernica* in the surrealist space of a museum, where the figures once again emerge from the painting: an arm carrying a lamp crosses the canvas, fragments fall to the gallery floor, a body rises. In playing with the endless metamorphosis of art images and images of the world, painting thereby replays its own history.

3.3 It does this perhaps more discreetly in the third manner in which art faces history, no longer playing with the construction of symbols

or commentary on images–signs, but with the possibilities of the figure. This manner takes its inspiration from the poetics I called *(sur)realist*, which employs all the transformations of the figure and relationships between figures that characterize a form of figuration freed from the rules of representation. You will recall the figuration dilemma once posed by Sartre. On the one hand, the authentic painter of the horrors of the twentieth century would cause Beauty to flee, along with the spectator. On the other, the 'traitor' who painted a concentration camp as you would paint a fruit bowl, would be equally unfaithful to the demands of art and the demands of history. The sur(realist) tradition swiftly found a way out of this dilemma. It did not paint the horrors of the war or of the dictatorships, but nor did it forget these in favour of fruit bowls or coloured forms alone. It painted things that provoke neither horror nor indifference: the human subject in the process of becoming inhuman. 'The lack of the human in man.' The expression is Giorgio de Chirico's, referring to a picture he once saw in an old book of something no human being had ever seen: a landscape from the Tertiary Period. Chirico claims he found this

89

landscape from before man in the storied paint-
ings of Arnold Böcklin, Nicolas Poussin and
Claude Lorrain. But it is to that landscape that
the combatants of the Great War also returned,
when they were made vegetal and mineral under
the brush of Otto Dix. Just as Chirico's man-
nequins and 'metaphysical' urban views come
alive in *Prague Street* and a host of other pictures
that marry expressionist fury and the coldness of
the 'new objectivity' to mark the monstrousness
of a society. Just as they will be figured again in
magic realism and surrealism to produce the
history paintings of a new genre that mark an
age of history and take the pulse of a civilization
by placing modern characters in settings from
Antiquity or virgins from Antiquity in front of
railway stations in Flemish squares. Illustrators
of Oswald Spengler such as Carel Willinck,
readers of the classics on dreaming, from
Salvador Dali to André Masson and Hans
Bellmer, witnesses for the prosecution in the
collapse of democracy in Germany, from Dix
and Grosz to Nussbaum and Hofer – all paint
what we might call, hijacking another of
Chirico's phrases, the spectre of history.

The lack of the human in man can be marked in many different ways, such as by the deformations of caricature and montage that bring out the ferocity of the animal or the stupidity of the vegetal in the figure of the leader (Merrill C. Berman's and John Heartfield's photomontages); by complete transformations and simulacra of the human face, such as Dix's gas masks, which turn into the masks of comedy or death; by the revival of *vanitas* iconography, grotesques and death dances, from Mafai to Nussbaum; by plastic equivalences between the grimaces of power and pictorial games. André Bazin once explained how *The Great Dictator* settled a case of moustache theft between Chaplin and Hitler. Similarly, a case of stolen pictorial features that needed to be recovered enlivens Kokoschka's caricatural outline (*Red Egg*), the schematic stroke of Klee's drawings (*Heil* or *Närrische Jugend*), Dix's Hitler in clown masks (*Masks as Ruins*) or Nussbaum's newly anonymous face of Hitler melting into the crowd (*Storm*).

It was the 'apolitical' Chirico who further named one of the major processes of '(sur)realist' history painting: the 'plastic solitude' of figures,

that is to say the deliberate dissociation of their *disposition* and their *exemplary* value. Painting the 'inhuman' means setting out places and figures in a kind of history painting that declines to make any comment. In Nussbaum's *Prisoners in Saint-Cyprien*, all the elements seem to have been brought together to create a meaningful scene. The painter describes his experience, captured while it's happening. He distributes his groups of figures according to the rules of composition. And, in the foreground, he places the 'concrete' scene of a geography lesson that brings together four allegorical figures from the Haggadah – the bad man, the wise man, the oblivious man and the naive man. It's just that the figures don't maintain any of the relationships their disposition implies: the real–allegorical expression freezes into a mask-like grimace, their eyes don't meet, they look elsewhere, nowhere. The *dispositio* cancels the story it was telling and the fable it created within that story in order to clarify it. Humanity realistically represented is a humanity that has withdrawn – like the face of the *Jew at the Window* which is not so much a victim's face, frightened or resigned, as a seer's face, already removed from

humanity, witness to a cataclysm even more astonishing than it is horrible. This is a look that abandons understanding and, by the same token, leaves the inhuman exposed, beyond any attempt to trivialize it.

So, the felt outrageousness of history never ceases to find pictorial expression. Emerging from the Great War, Chirico renews history painting by re-painting the most moving of departures for battle: the farewells of Hector and Andromache, who are simply replaced by mannequins. In the 1940s, the Jewish exile Felix Nussbaum, in his hiding-place in Amsterdam, painted an allegory of the camps and the death that awaited him there, in his figures with their frozen expressionism, while, on the shores of Lake Constance, Karl Hofer turned them into ghosts in his own way, in the calmly inhuman disposition of the perpendicular panels and solitary, naked figures of *The Black Room*. In 1990, Larry Rivers, the son of Jewish immigrants and the same man who had demystified Washington's iconography, painted two quietly symbolic portraits of Primo Levi, the witness to the camps. In one, the writer's face splits in two to reveal the face of the internee. In the other, the movement

of his hand unfurls the camps' landscape of walls and victims' silhouettes. It is a superimposition borrowed from cinema, a breaking-down of movement borrowed from the ancestral chrono-photography of Edouard Marey. History isn't done yet with turning itself into stories.

Films cited

Germany Year 90 Nine Zero (*Allemagne neuf zéro*)
Jean-Luc Godard, France, 1991

Workers Leaving the Factory (*Arbeiter Verlassen die Fabrik*)
Harun Farocki, Germany, 1995

Images of the World and the Inscription of War (*Bilder der Welt und Inschrift des Krieges*)
Harun Farocki, Germany, 1988–9

Mother Dao, the Turtlelike (*Moeder Dao, de schildpadgelijkende*)
Vincent Monnikendam, Netherlands, 1995

Dynamite (*Dinamite*)
Daniele Segre, Italy, 1994

Drancy Avenir
Arnaud des Pallières, France, 1996

Phantom Efremov (*Le fantôme Efremov*)
Iossef Pasternak, France, 1992

Fortini/Cani
Jean-Marie Straub and Danièle Huillet, Italy, 1976

Histoire(s) du cinéma
Jean-Luc Godard, France, 1989

Listen to Britain
Humphrey Jennings, United Kingdom, 1941

People on Sunday (*Menschen am Sonntag*)
Robert Siodmak and Edgar G. Ulmer, Germany, 1929

Words and Death. Prague in the Days of Stalin (*Les Mots et la mort. Prague au temps de Staline*)
Bernard Cuau, France, 1996

Night and Fog (*Nuit et brouillard*)
Alain Resnais, France, 1955

Shoah
Claude Lanzmann, France, 1985

The Last Bolshevik (*Le Tombeau d'Alexandre*)
Chris Marker, France, 1993

Videograms of a Revolution (*Videogramme einer Revolution*)
Harun Farocki and Andrej Ujica, Germany, 1991–2

Rothschild's Violin (*Le Violon de Rothschild*)
Edgardo Cozarinsky, France, Switzerland, Finland, Hungary, 1996